Down a Country Road
West Virginia Through a Lens

Justin Brewer

Copyright © 2015 Justin Brewer

All rights reserved.

ISBN: 14595992020
ISBN-13: 978-1495992025

DEDICATION

This book is dedicated to my wife, Laura, who is immensely patient with my wanderings and my photographic experimentations. Also, it is dedicated to my son Gabriel, who is my back road exploration buddy, and to my other son Isaac who will surely join us one day in wandering.

CONTENTS

	Acknowledgments	i
1	Introduction	1
2	Landmarks	4
3	Nothing but Coal	10
4	Waterfalls	13
5	Barns	18
6	Ruins	22

ACKNOWLEDGMENTS

I would like to acknowledge my good friend and fellow photographer, Phil Berry, for his pointers and instruction, as well as his willingness to share his "sweet spots" for photography. May he never let on that he is the better photographer!

1 INTRODUCTION:
RICH IN HISTORY AND CULTURE...AND THE OUTDOORS

The history of West Virginia is filled with stories, characters, and conspiratorial events that would put to shame even the best creative writer. From rough and rowdy clansmen such as William Anderson "Devil Anse" Hatfield and his epic feud with Randolph McCoy have grown myths and legends concerning the backward, but tough nature of the state. Likewise, the much disputed coal industry has provided fodder for stories, books, movies, plays, and music. And yet, the wealth of the state has often been found in this particular industry and has both harmed and helped the populace of the state. Congruent with the coal industry is the often debated concept of unionizing; here, again, West Virginia has a "rough and rowdy" reputation!

Thanks to mainstream media, the Hatfield and McCoy feud is perhaps the most popular feud in history, perhaps to be equated to the fictionalized feud found in Shakespeare's *Romeo & Juliet*. These were not the only influential individuals in the history of the state, however. Rather, add to this list men and women such as Homer Hickam, the infamous NASA engineer and author of *Rocket Boys*; Don Knotts, famous for his portrayal of Barney Fife; Brad Paisley, the musician; and Pearl S. Buck, authoress of *The Good Earth*. This is, of course, a non-comprehensive list! In fact, many do not realize that even the Confederate General Thomas Jonathan "Stonewall" Jackson was actually born in part of what is now West Virginia, although it was still a part of Virginia in the pre-Civil War era.

Founded conspiratorially, West Virginia has long been a state that has largely been unrecognized by much of the nation. West Virginia was initiated into the Union as a state in the midst of the Civil War on June 20,

1863. Because President Abraham Lincoln proclaimed the statehood of West Virginia[1], many at the time questioned the legality of the move and, as a result, many citizens that were sympathetic to the Confederate cause were inflamed. And yet, the state endured! Even today, however, West Virginia is a forgotten state; if you do not believe this to be true, tell someone that you are from West Virginia and see how quickly they ask you how close you live to Richmond!

While much attention is given in history courses to the pivotal Civil War battles such as Gettysburg, West Virginia had its fair share of warfare. Droop Mountain, Harpers Ferry, and Carnifex Ferry are just a few of the battles fought on the steep, rugged terrain so common in the state.

Many of the previously mentioned battlefield sites now offer the locals and visitors the opportunity to learn about the events that transpired on that ground, as well as hiking, fishing, camping, and other outdoor activities. While some of these State Parks are relatively small, they still offer wonderful insight into West Virginia history. In many instances, there are spectacular views from easily accessible platforms provided by the state that will take your breath away! For instance, in the Droop Mountain Battlefield State Park (droopmountainbattlefield.com) there is an observation tower that provides a gorgeous view for miles of the surrounding terrain. Likewise, the observation deck at Carnifex Ferry State Park offers a wide angle view of the Gauley River where the observer can hear the whitewater rapids!

West Virginia offers a lot of beauty and a lot of outdoor activities for those that are looking for them. There are numerous hiking trails marked throughout the Monongahela National Forest and many areas assigned for camping (http://www.fs.usda.gov/mnf), which also offers the Cranberry Glades to nature and botanical enthusiasts. There is also a wonderful learning center in the heart of the forest where the employees are eager to teach all visitors about the wildlife and plant life of the forest; they also keep numerous live reptiles, most of which are caught in the forest and provided for learning purposes. Within the forest runs two wonderful trout rivers: the Cranberry and the Cherry, and this is just the section of the forest the runs near Richwood, West Virginia! The forest actually connects with other state forests, such as Seneca State Forest, and Canaan Valley State Park. Hikers, campers, fishermen, and photographers could spend days in this region and still not be able to see everything!

[1] Perdue, John. "West Virginia History & Interesting Facts." *West Virginia History & Interesting Facts*. N.p., 2013. Web. 18 Feb. 2014.

One does not have to go to a predestined "tourist" area in order to find beauty in West Virginia, however. As an amateur photographer, some of the most beautiful photos I've taken have been from my truck while simply exploring a random back road with my young son. West Virginians have long been farmers of hard, rugged land, and so old barns (which make wonderful photography material) can be found just about anywhere and in the most unique places. For instance, there is an old barn near Summersville that is positioned over a small cave! There are other unique sites to see as well; such as miniature pony farms, longhorn cow farms, and homes built essentially into the side of a boulder!

West Virginia truly offers a wide range of photographic material, which is the main purpose of this book. Many of the images contained in this volume were captured while on short hikes or long vehicle rides. There are wonderful shots available to any photographer no matter what season it may be; each season offers its own unique beauty to the lens of a camera…just be on the lookout for anything that catches your eye!

The introduction is the most text-heavy portion of this book; from here on out there will be short descriptions to accompany each photograph and perhaps some advice aimed at other newbie photographers on how to capture similar images; most advice is based on pointers that have been given to me by professional photographers through either personal instruction or through the reading of their books. Mostly, it is based on what seems to have worked best for me. I hope that it is helpful and beneficial! And if you are simply purchasing/reading this book for the photographic component, then please enjoy in spite of the advice!

2 LANDMARKS

West Virginia has many landmarks that are relatively famous, so it is not the intent of this chapter to include every single one of them. However, there will be a few that will either look familiar to you or will incite you to want to explore West Virginia in search of them!

BABCOCK STATE PARK

One of the most photographed grist mills in the world resides in southern West Virginia. The Glade Creek Grist Mill, located in Babcock State Park (babcocksp.com), is a photographer's dream in the autumn season. In fact, photos of this mill have found their way clear to Romania where some locals will claim that it is in the Carpathian Mountains; alas, it is actually an occasionally working mill in West Virginia. The current mill was completed in 1976 and is a recreation of the original mill that sat on the same property, but is still a fully operational mill.[2]

Babcock State Park is surrounded by some stunningly beautiful landscapes; from classic homesteads that seem to have been there for generations to rugged, deep canyons. This region offers wonderful photography opportunities! Within the park itself, there are rivers, waterfalls, old bridges, old stone walls, hiking, canoeing, and Boley Lake, which is located high up on the mountain behind the Glade Creek Grist Mill.

[2] The Official Site of Babcock State Park." *Babcock State Park*. N.p., n.d. Web. 19 Feb. 2014.

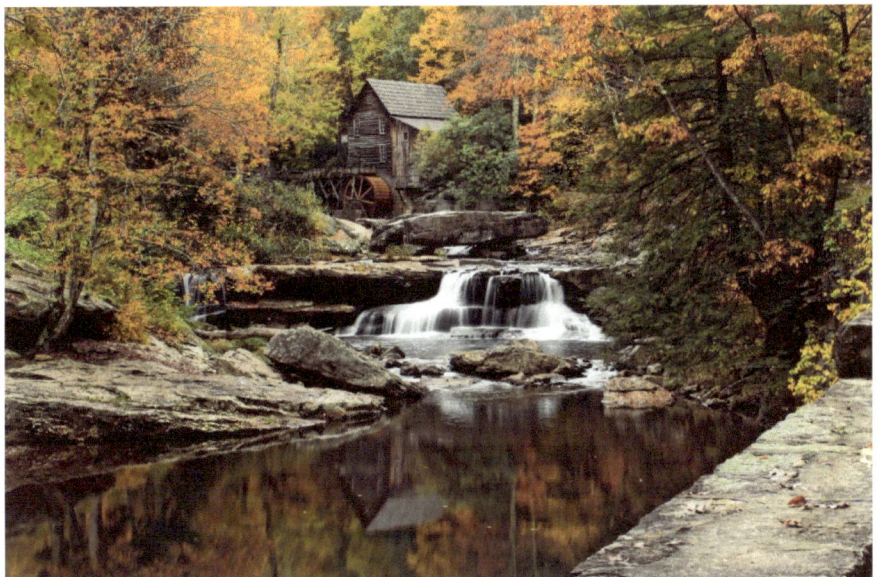

Fig. 2.1 Glade Creek Grist Mill, October 2012

Pictured above (*Fig. 2.1*) is the mill in one of its most popular seasons: autumn. On a day with beautifully colored leaves and a slightly overcast sky, it is difficult to get a good, clean shot of the mill.

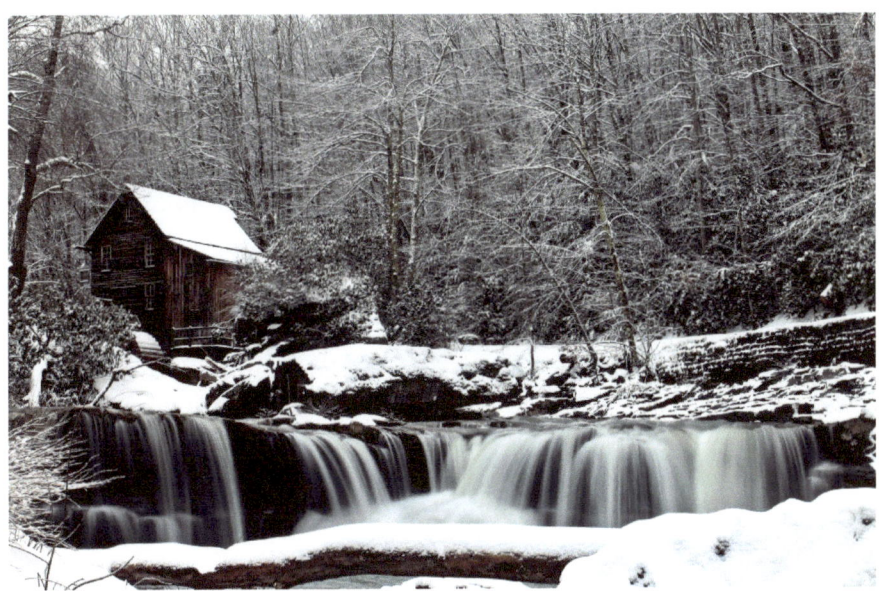

Fig. 2.2 Glade Creek Grist Mill, March 2013

Winter offers a whole new set of challenges, particularly if you like the silky effect on the waterfall. Snow makes it rather difficult to have a long exposure without causing the snow to be washed out. This image (*Fig 2.2*) was initially captured using both a UV filter and a CPL filter.

As stated before, there are numerous things to do and to photograph in Babcock State Park. Pictured below (*Fig. 2.3*) is an autumn shot of Boley Lake. This seems to be a particularly peaceful lake where both hiking and boating are encouraged. In fact, there are boats available for renting depending on what time of year you venture there.

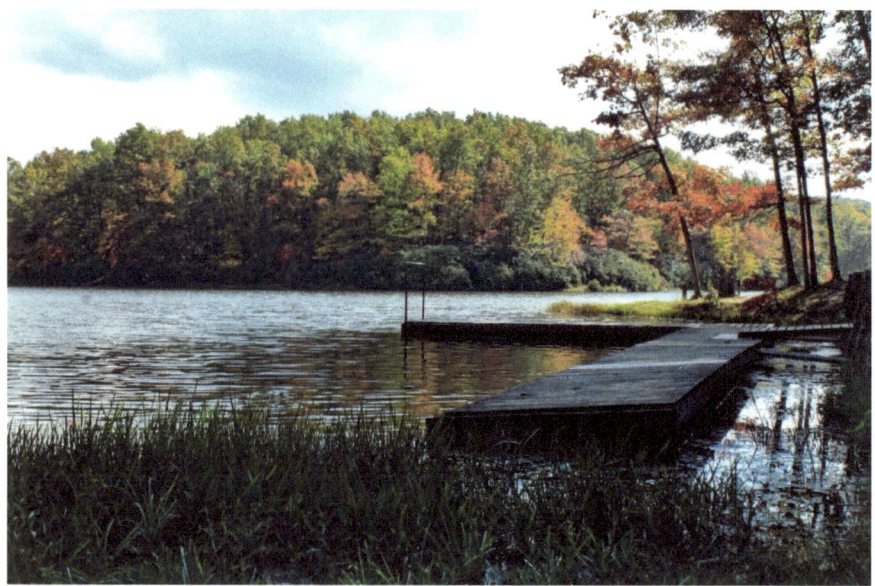

Fig. 2.3 Boley Lake, October 2012

COOPERS ROCK STATE FOREST

One of the more popular outdoor destinations for West Virginia University[3] students is the nearby Coopers Rock State Forest[4]. There are numerous picnic structures and areas, hiking trails, and for the more courageous adventurer, rock climbing. The view of the surrounding region from the vast platforms is truly amazing and well worth a visit…with a camera.

[3] www.wvu.edu
[4] www.coopersrockstateforest.com

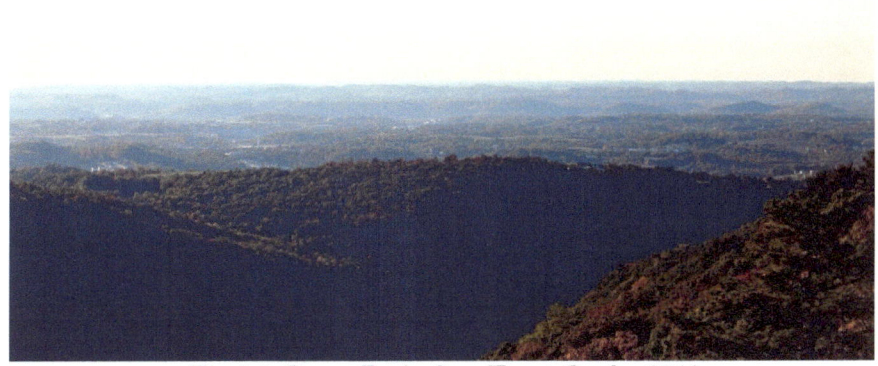

Fig. 2.4 Coopers Rocks State Forest, October 2012

HAWK'S NEST STATE PARK

Located in the southern part of the state is Hawk's Nest State Park, which offers some great views from a very high elevation. The roads in and around Hawk's Nest are particularly curvy and steep, but there are some wonderful photographs to be taken there as well.

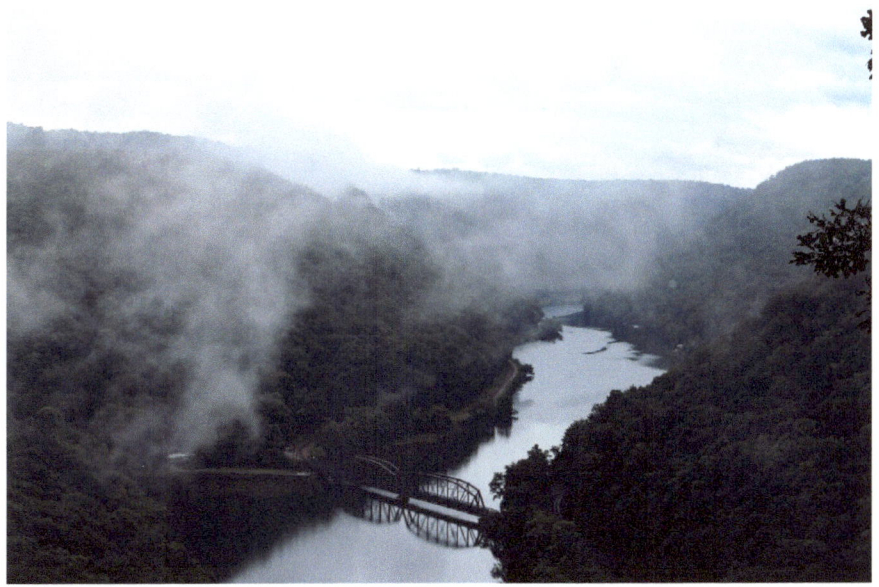

Fig. 2.5 View from the Hawk's Nest Overlook

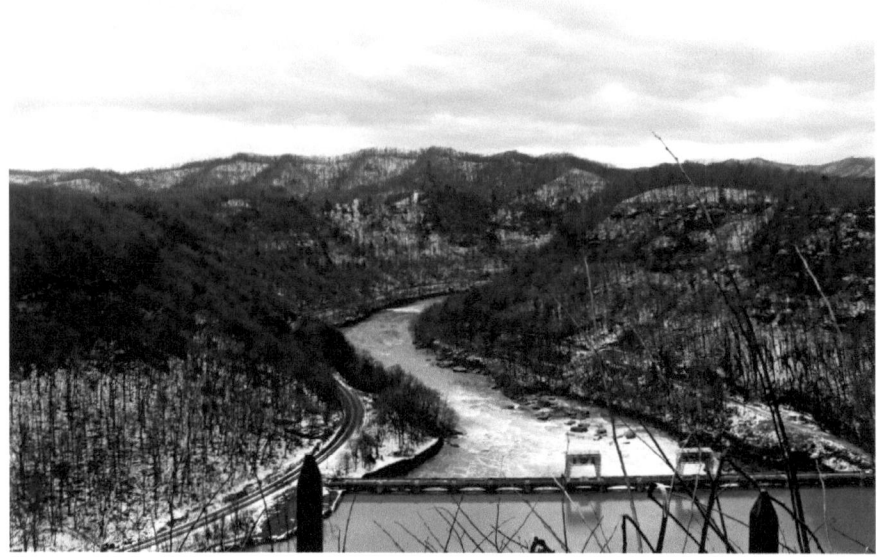

Fig. 2.6 View of the Dam Below Hawk's Nest

There are many other state and national parks within the borders of West Virginia; in this last section, there are photos from various parks, all uniquely beautiful in their own right. Visit www.wvstateparks.com for more information on the location, attraction, and directions to West Virginia parks.

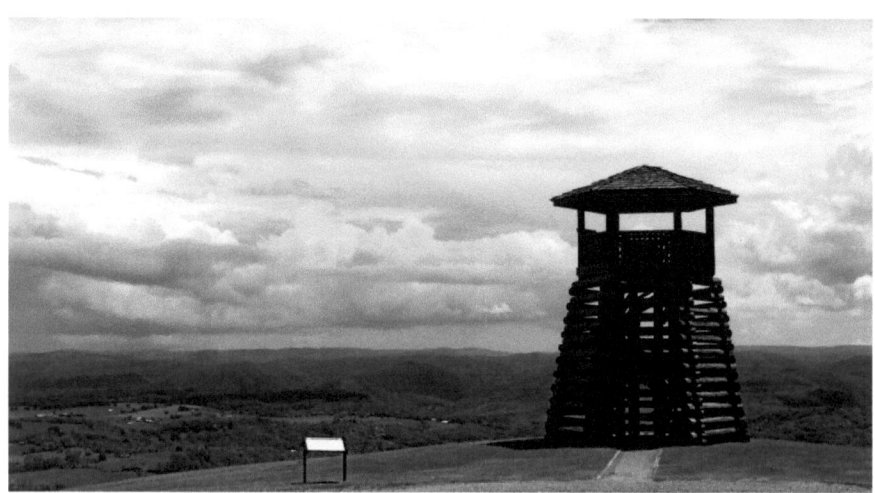

Fig. 2.7 Observation Tower at Droop Mountain

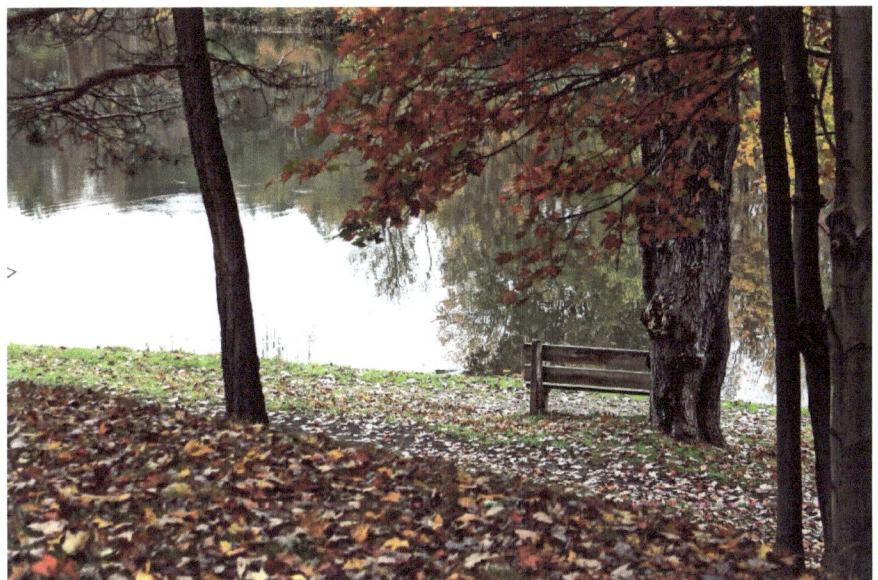
Fig. 2.8 A Fall View of the Lake in Tomlinson Run State Park

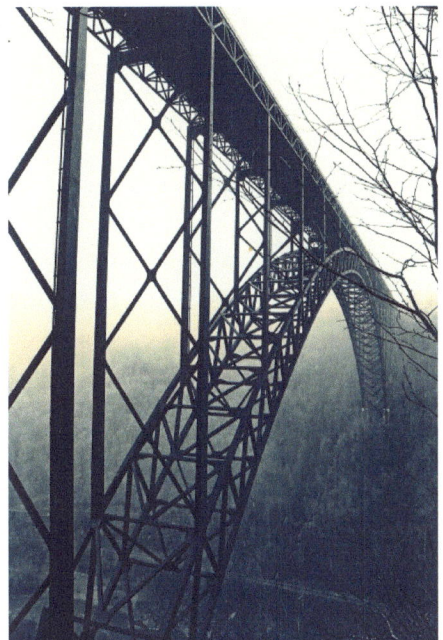
Fig. 2.9 New River Gorge Bridge

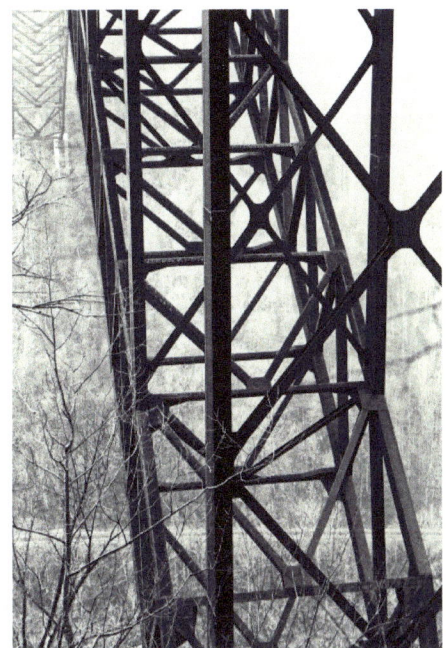
Fig. 2.10 Structural View of the Bridge

3 NOTHING BUT COAL

The coal industry has long been a vitally important part of both the West Virginia economy and history. As such, the industry provides some very unique photo opportunities in addition to historical values. For this section, we will predominately focus on the ghost coal town of Nuttallburg,[5] which is located only a few miles from the New River Gorge Bridge. This town was thriving in the mid to late 1870s and continued into the 1900s. The Nuttallburg mines, named after John Nuttal, were even owned by the famous Henry Ford at one point in their history. Today, they are but a shadow of their formal glory, but they remain a place of intrigue for any willing to bounce down the rugged road leading to them today.

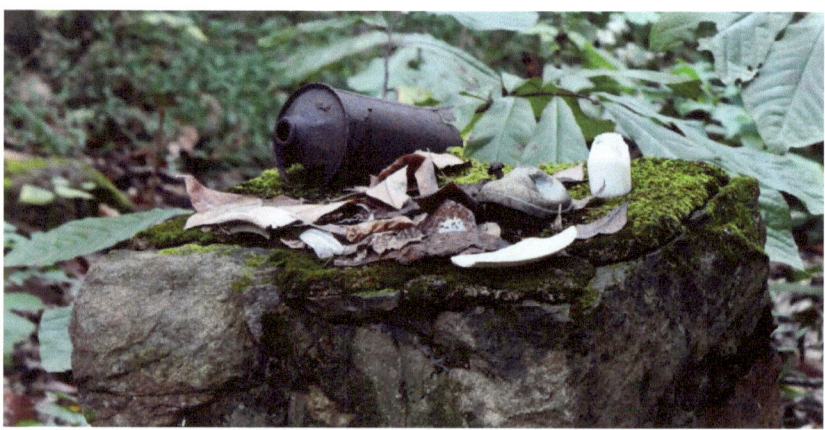

Fig. 3.1 Remains of a Past Life

[5] http://www.nps.gov/neri/historyculture/nuttallburg.htm

Fig. 3.2 are the remains of the Nuttallburg company store. They are now well overgrown, but visitors to the park are welcome to walk inside and view a few of the rusty remains of equipment and who knows what else. Not much else remains to be spoken of, just little bits of trash from the past. Many visitors to the park discover historical items, anything from old ceramic pots, to canning jars, to bits of metal and coal, to children's marbles. As with most parks, visitors are asked to leave such tidbits behind for others to find (as in Fig. 3.1, which contains an old bottle, parts of a leather shoe, and broken pottery shards). That element of discovery, even after so many have gone before, adds a wonderful element to this national park.

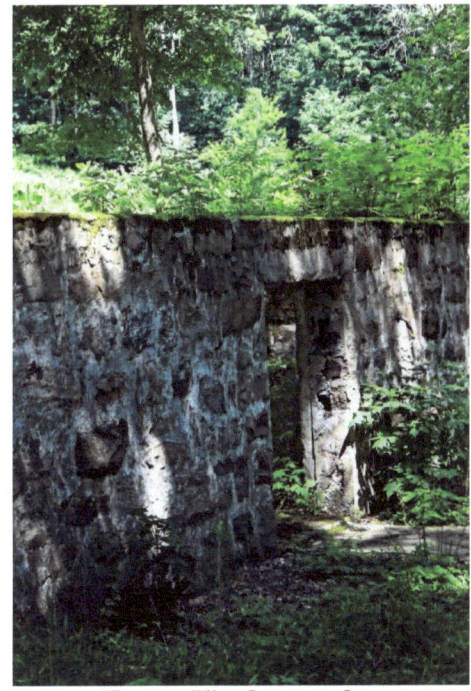

Fig. 3.2 The Company Store

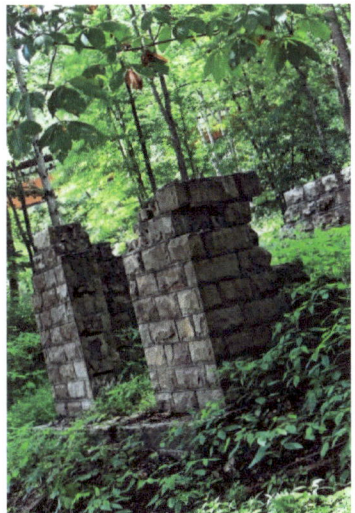

Fig. 3.3 Ruins Along the Train Track

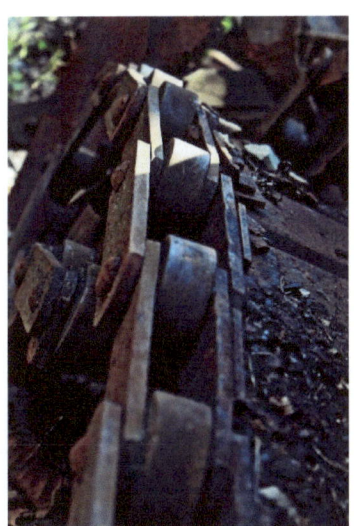

Fig. 3.4 Rusty Machinery

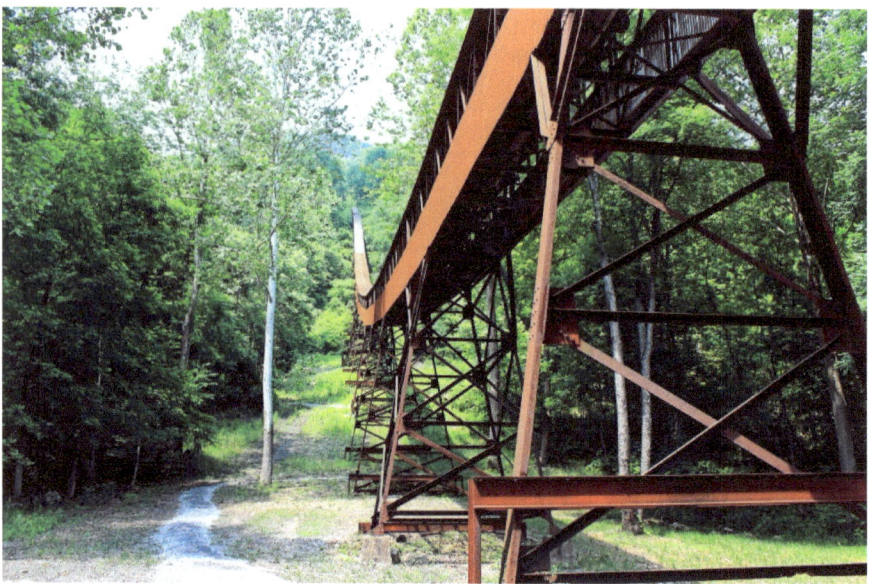

Fig. 3.5 Nuttallburg Coal Tipple

Since Nuttallburg is in the New River Gorge, the mountains are rather steep and majestic. One fascinating sight is the coal tipple that runs from just above the river to the top of the mountain. There is a trail that leads to the mouth of the mine entrance, but as can be seen from the photograph (Fig. 3.5), it is particularly steep.

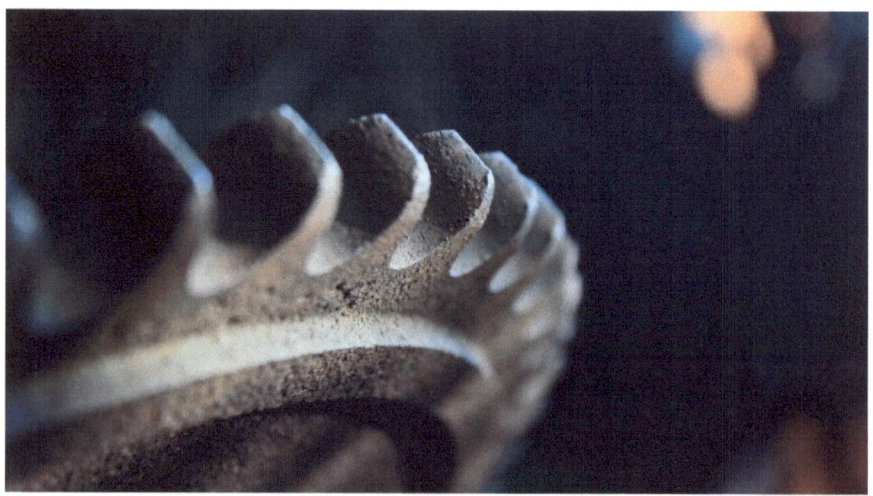

Fig. 3.6 Rusty Gold

4 WATERFALLS

The mountains of West Virginia are filled with beautiful waterfalls, from small creek falls to awe-inspiring waterfalls like Blackwater. Some waterfalls coincide with state landmarks, as with the Glade Creek Grist Mill in Babcock State Park (fig. 2.1 & 2.2). The waterfalls of West Virginia have filled the pages of photography books and have drawn photographers (professional, amateur, and everything in between) together on modern social media sites. For the photographer, these waterfalls offer the opportunity to connect with nature, relax, listen to gentle streams or raging whitewater, and even practice artistic abilities with long exposures (which create a smooth, silky effect with water).

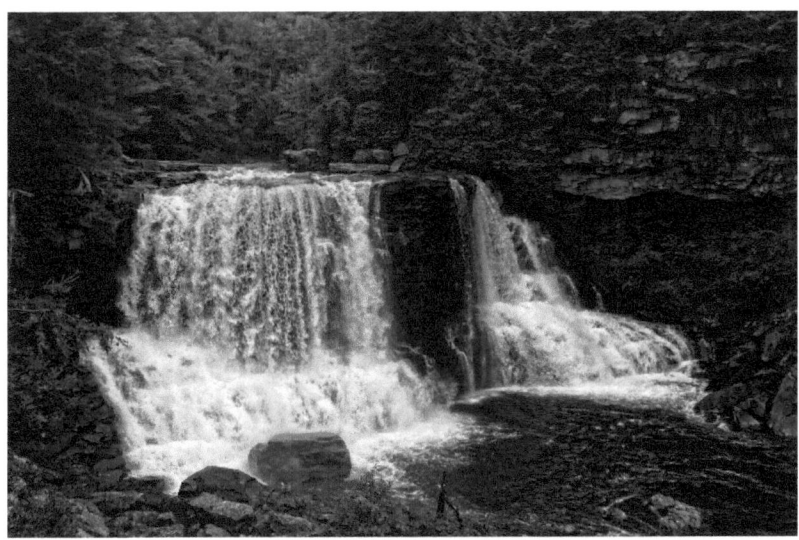

Fig. 4.1 Blackwater Falls

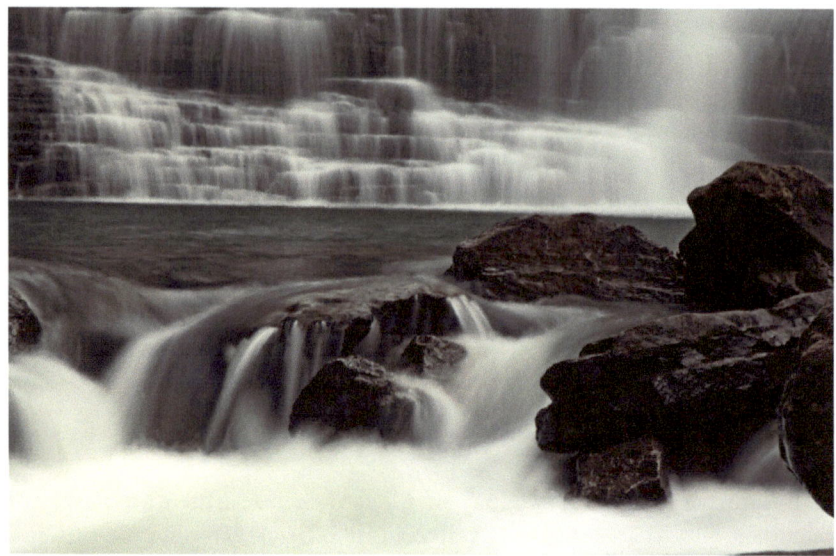

Fig. 4.2 Peters Creek Falls

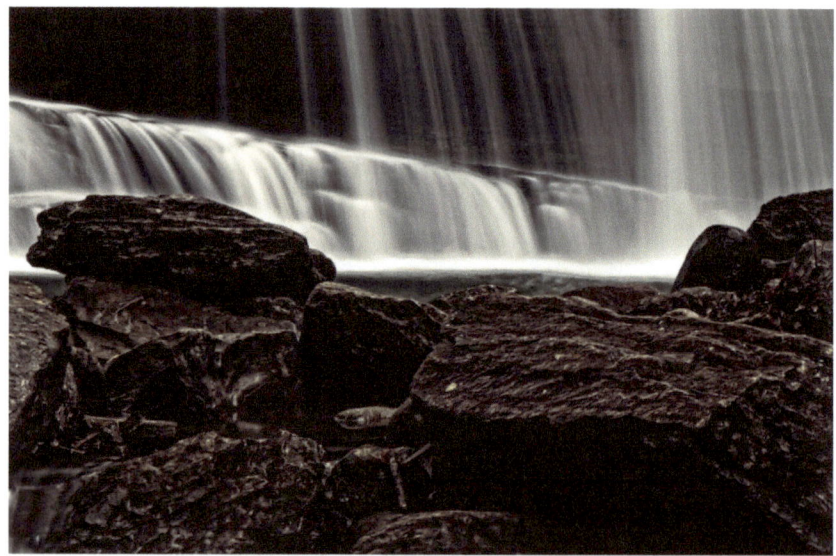

Fig. 4.3 Peters Creek Falls

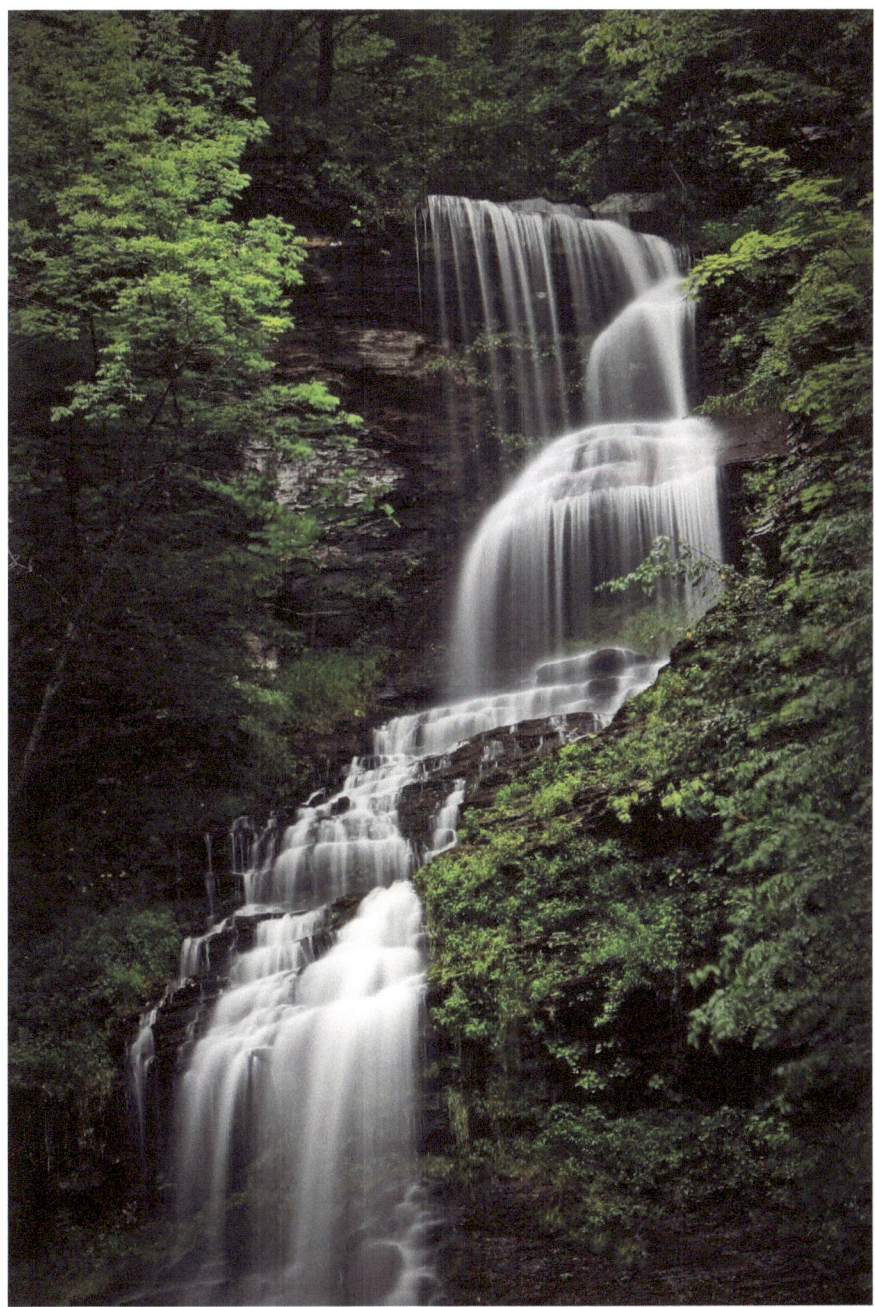

Fig. 4.4 Cathedral Falls

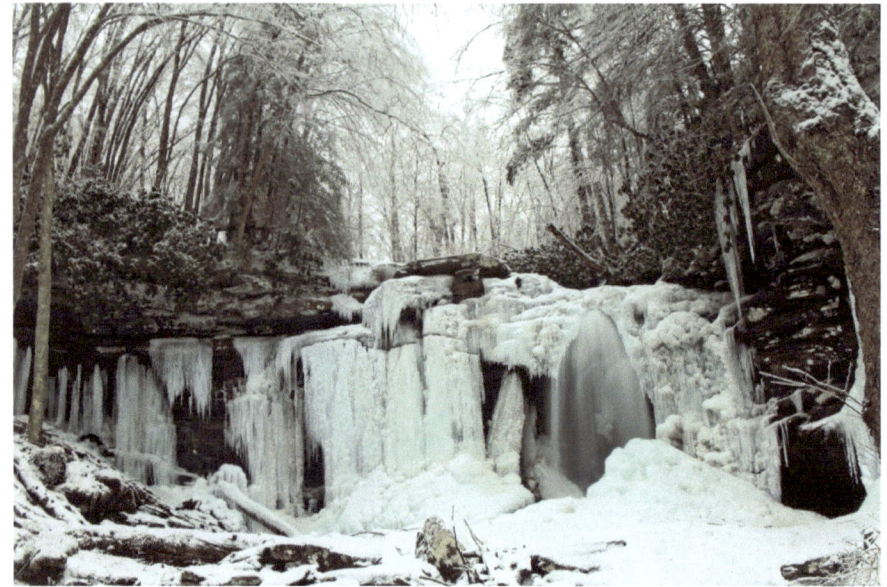

Fig. 4.5 Frozen Falls of Hills Creek

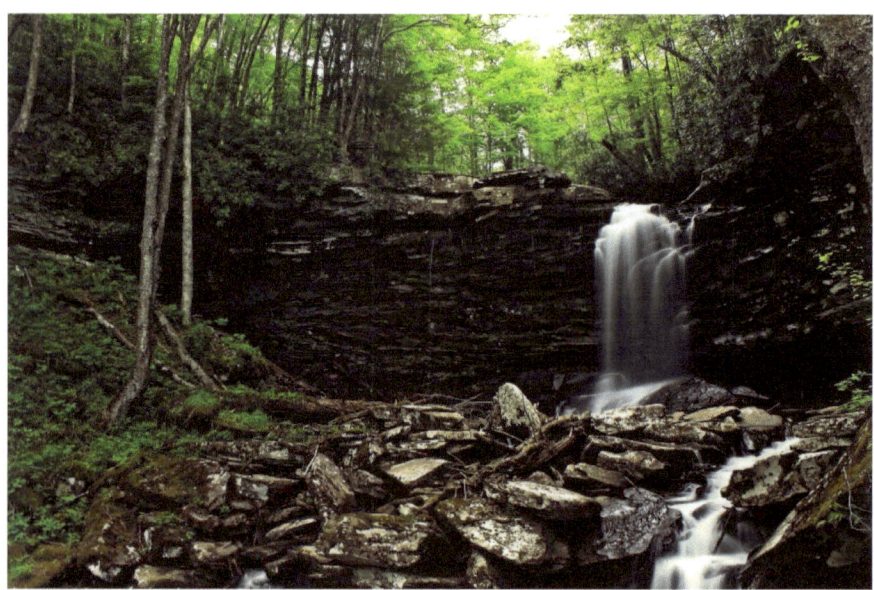

Fig. 4.6 Spring Falls of Hills Creek

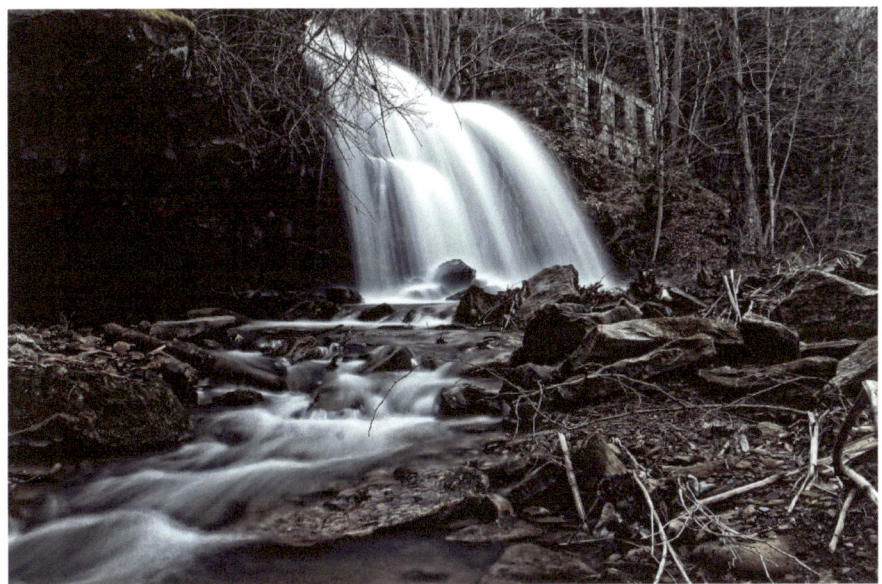

Fig. 4.7 Mill Creek Ruins and Waterfall

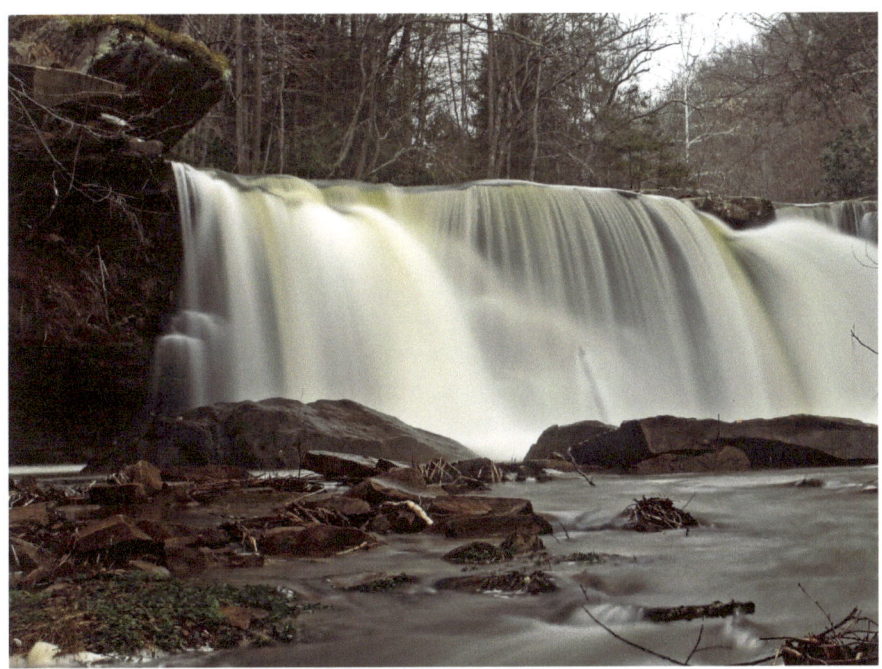

Fig. 4.8 Mill Creek Falls

5 BARNS

The West Virginia countryside is filled with barns that are still in use and many that are abandoned. Each type of barn has unique beauty no matter what condition it is in. Some, like Fig. 5.1, are picturesque with brilliant coloring, fencing, and a wonderful reflection. Others, like Fig. 5.2, are dilapidated and have a certain amount of mystery hidden amongst the decay. Many of West Virginia's country roads will lead a wanderer to beautiful settings filled with fields, rocks, gravel roads, and of course, a barn.

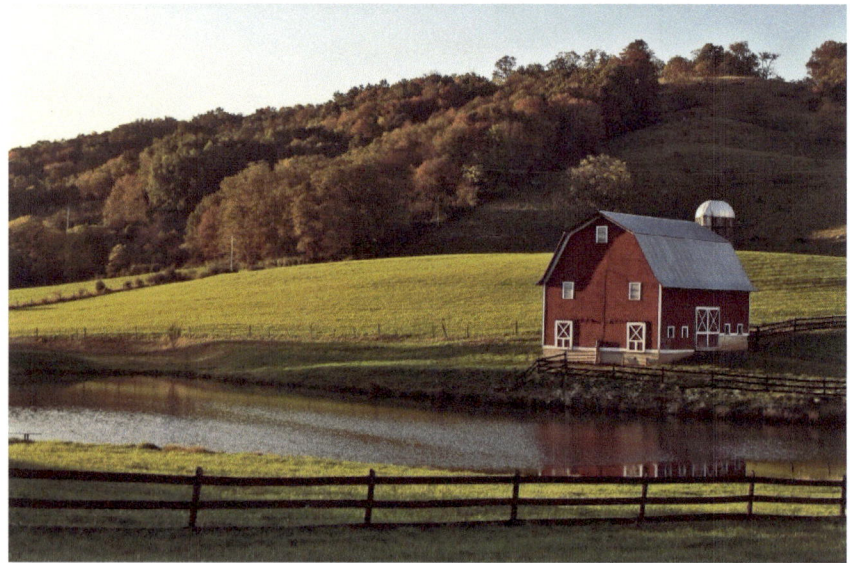

Fig. 5.1 Classic Red Barn in the Fall of 2013

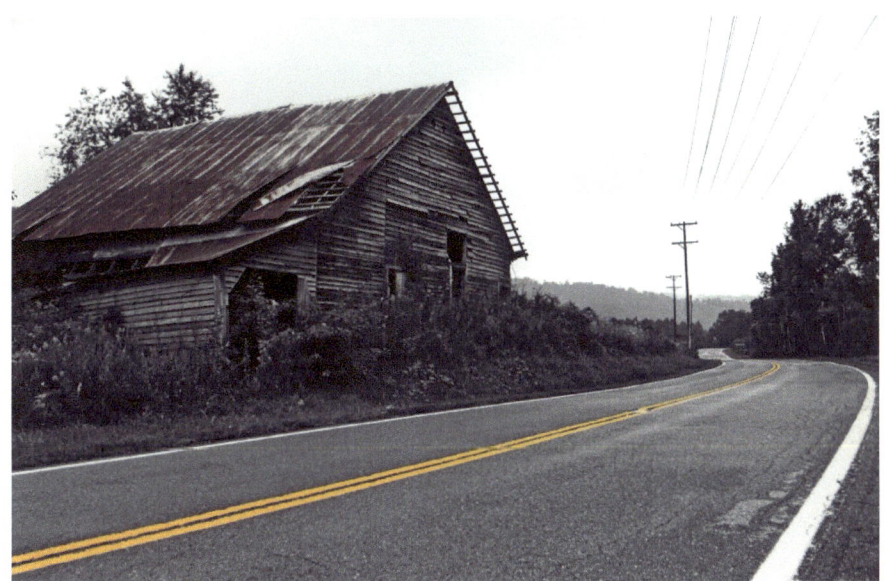

Fig. 5.2 Dilapidated Barn Near Summersville

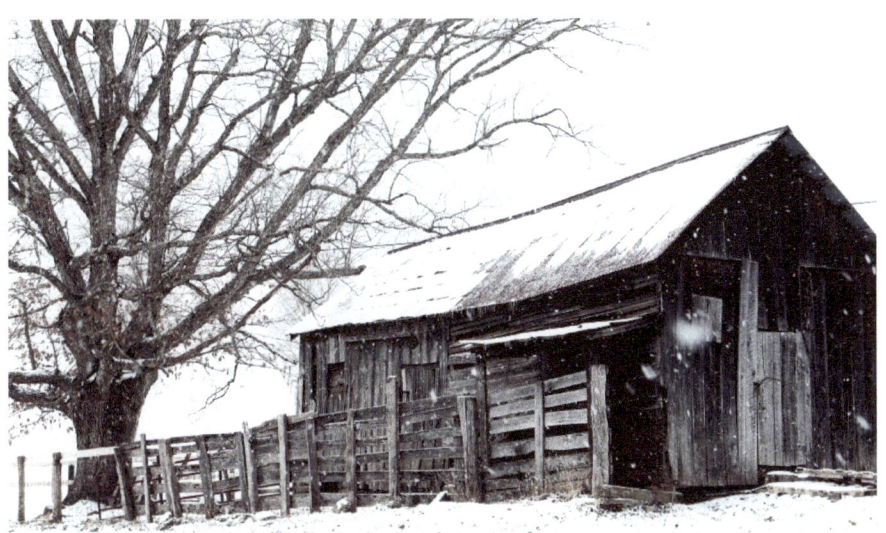

Fig. 5.3 Snowy Barn in Mt. Nebo

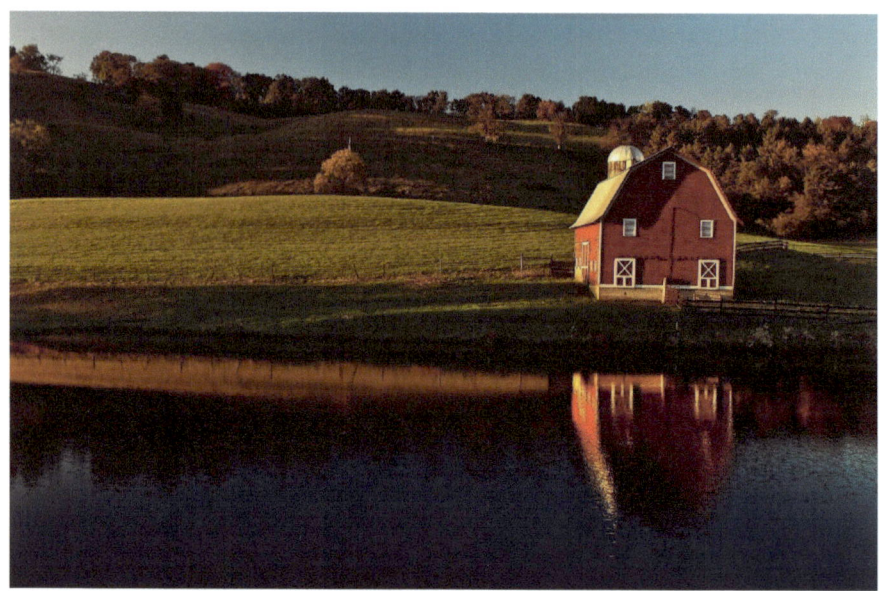
Fig. 5.4 Reflections in the Fall

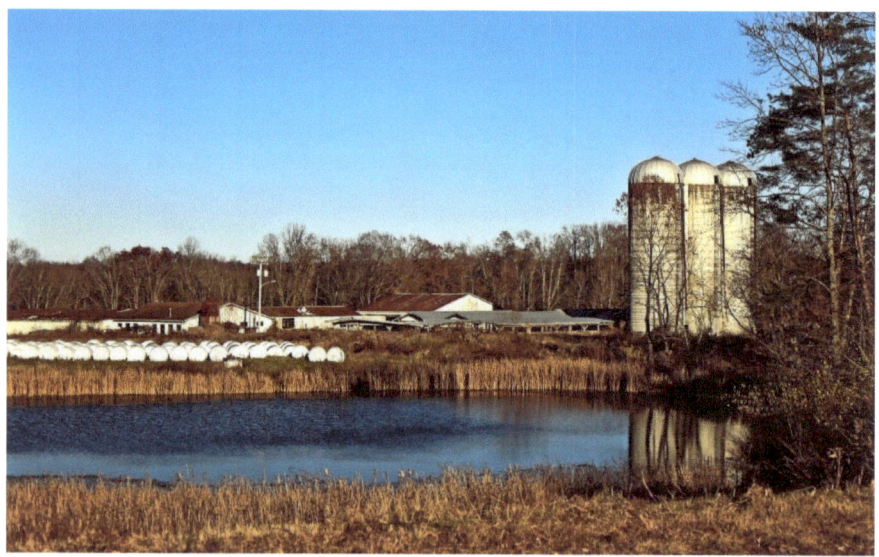
Fig. 5.5 Silo Reflections Near Summersville

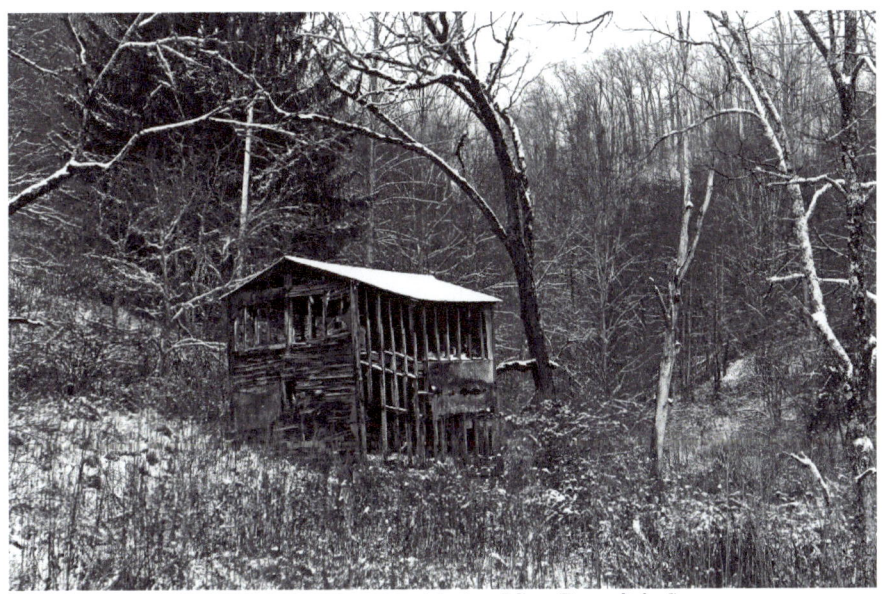

Fig. 5.6 Barn in Doddridge (Now Demolished)

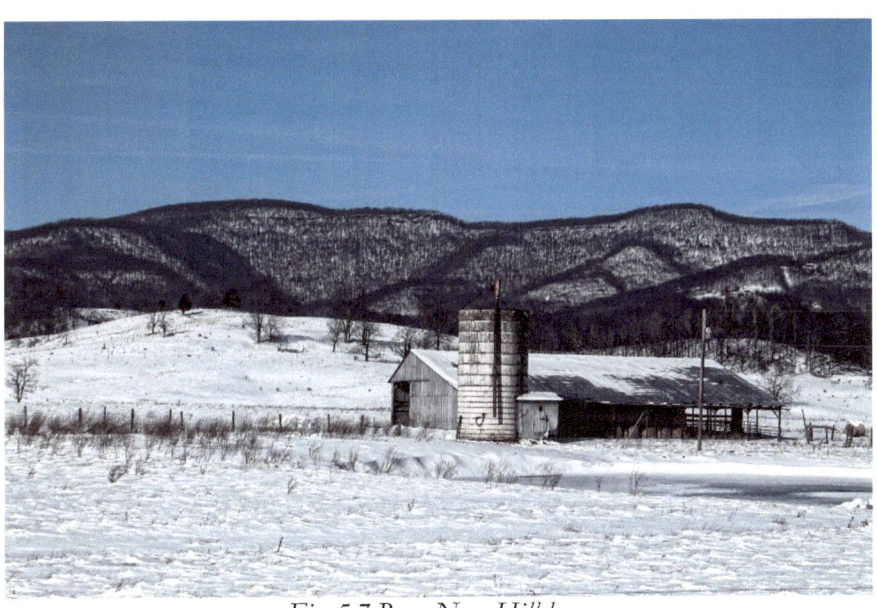

Fig. 5.7 Barn Near Hillsburo

6 RUINS

Beauty is, as they say, in the eye of the beholder. Located on many of West Virginia's back roads are numerous "ruins;" some have great value to local historians, to those of us that enjoy imagining the life of those that once lived there, and of course, to the photographer looking for a fun shot. Some ruins are elegant and mesmerizing, others are simply burnt out or dilapidated trailers. On occasion, a ruin can look like something out of a horror movie until someone sees the true beauty behind the ugliness.

For many people, the abandoned building holds mystery; what type of person lived there? What did they do on a daily basis? Were they rich or poor? Hardworking? In that type of mystery, one can find beauty. Tucked into the mountains of West Virginia are many buildings that make the viewer wonder such things; some are small shanties with no windows, some are larger dwellings that have served many functions since their construction, and some are abandoned places of business such as factories.[6] Compose a photograph of any such building and you will leave people pondering the historical significance of them!

One particularly popular aspect of "ruins" photography is that of the decaying barn, which becomes even more exciting should there be any period advertising painted on the side of it. Photographs of barns, antique tractors, and other older farm implements draw enthusiasts out of the woodwork. They aren't always "pretty" in the way a shiny new car is, but they have their own unique charm and charisma. Many of the regions in

[6] Please use caution when photographing such buildings. They are dangerous, and never cross private property without permission.

West Virginia not only provide a great many such old barns, but often place them in the most picturesque of settings.

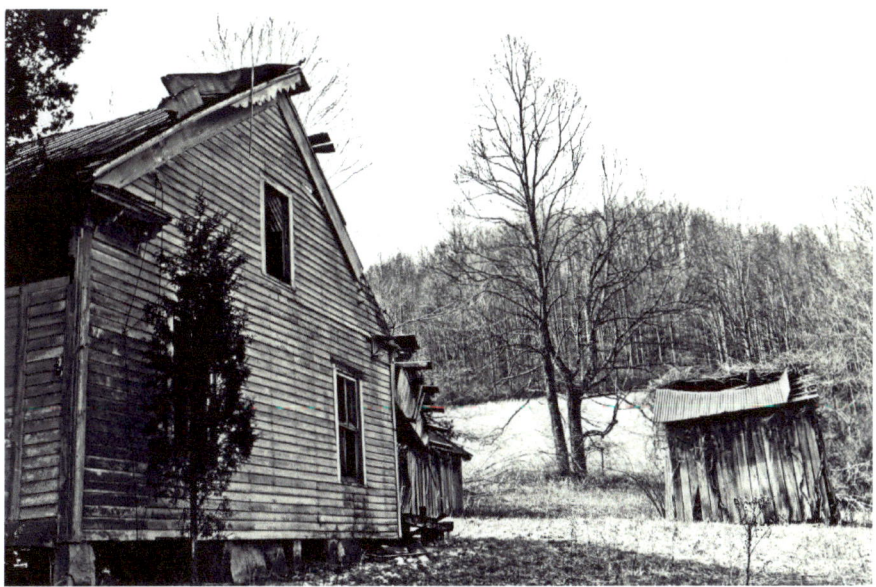

Fig. 6.1 Old Farmstead near Summersville, WV

Old farmsteads are prevalent throughout the state; sometimes the beauty can be found on a large scale (such as in Fig. 6.1), but other times the beauty is found upon closer inspection (Fig. 6.2).

Fig. 6.2 Same farmhouse, different perspective

Old homes always make me wonder about the lives of those that once lived there; why did they leave such a place? Why abandon it rather than sell it?

For many places, such questions will forever be unanswered...but part of the fun is the wondering.

In photographing ruins, it is always fun to find old signs of life. Oftentimes, there are "layers" of the past. This means that there are not only items or signs of life from the original occupants, but items that show signs of squatters and explorers. As always, if you explore such places, be extremely careful because such places can be very dangerous. You can see many such layers in Fig. 6.3; there is everything from the original woodwork, to added electricity, to homemade tables, to the remainder of a "no trespassing sign" nailed to the siding of the house. How did they all come to be on the same porch and not be moved over the years? Of course, these may be unanswerable questions, but they are fun for the back roads explorer to ask and ponder over.

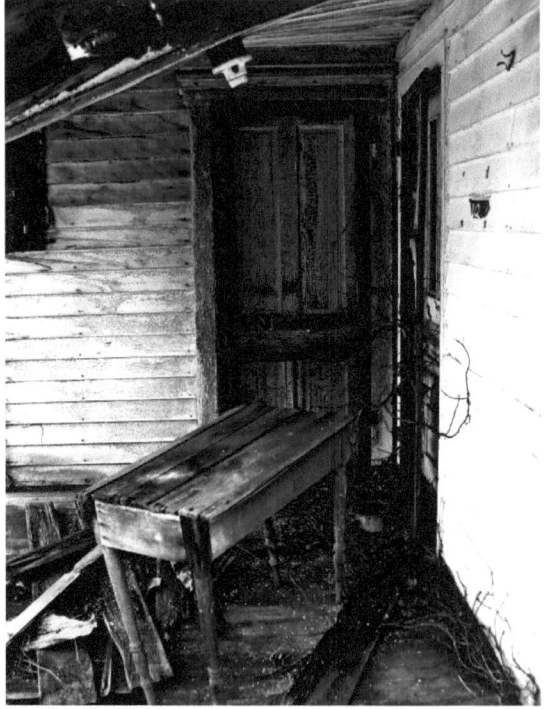

Fig. 6.3 Back Porch Living

Obviously, some ruins are leftovers from a by-gone era and depict life as it once was among the Appalachian mountain range. The citizens of this state have long made a livelihood in the hardest ways; anywhere from farming on rugged, steep mountain tops to building factories and businesses on the valley floor. Unfortunately, the West Virginian economy is more often down than up and much of the landscape is littered with abandoned homes, farms, and businesses because of this. Many are now fallen in, but some still remain standing enough to capture a creepy, yet fun "ruin" photograph. One such business hides between two rather rugged mountains in between Nettie and Richwood, West Virginia. What this business did is unknown to the author at the point of writing, but it made for some interesting shots (Fig. 6.4).

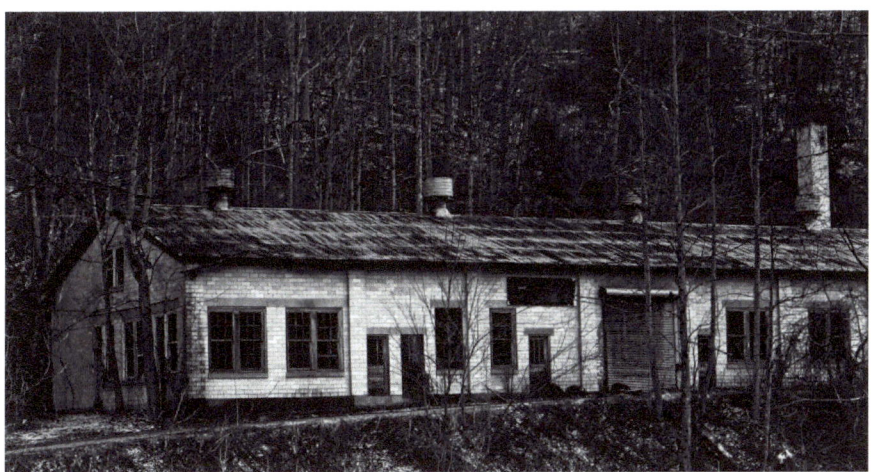

Fig. 6.4 Abandoned Business near Richwood, WV

Some ruins have served multiple purposes over the years; from a home, to a place of storage, back to a home, to a barn. Sometimes they serve the dual purpose of home and barn, unfortunately. That is the story behind Fig. 6.5.

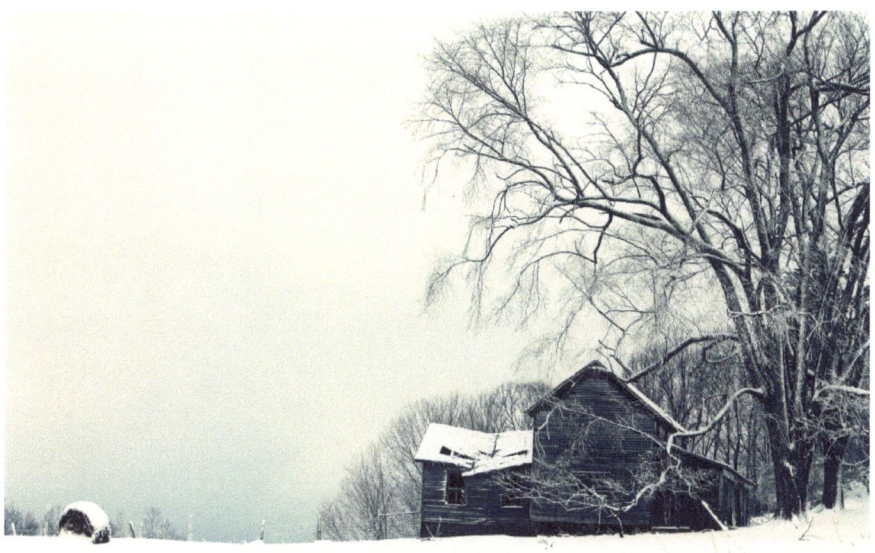

Fig. 6.5 A Multipurpose Home in Southern West Virginia

Figures 6.6 and 6.7 are closer views of the same old house, which holds a particularly creepy, yet charming draw to the back road explorer.

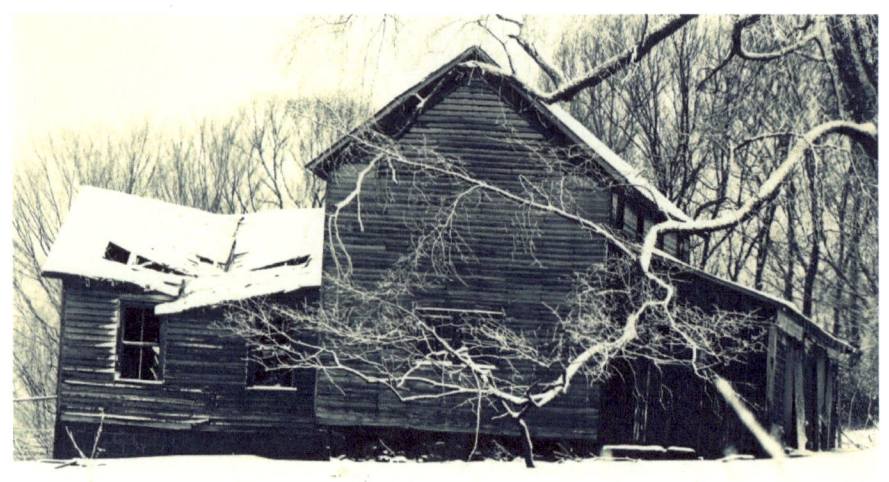

Fig. 6.6 Dual Purpose House

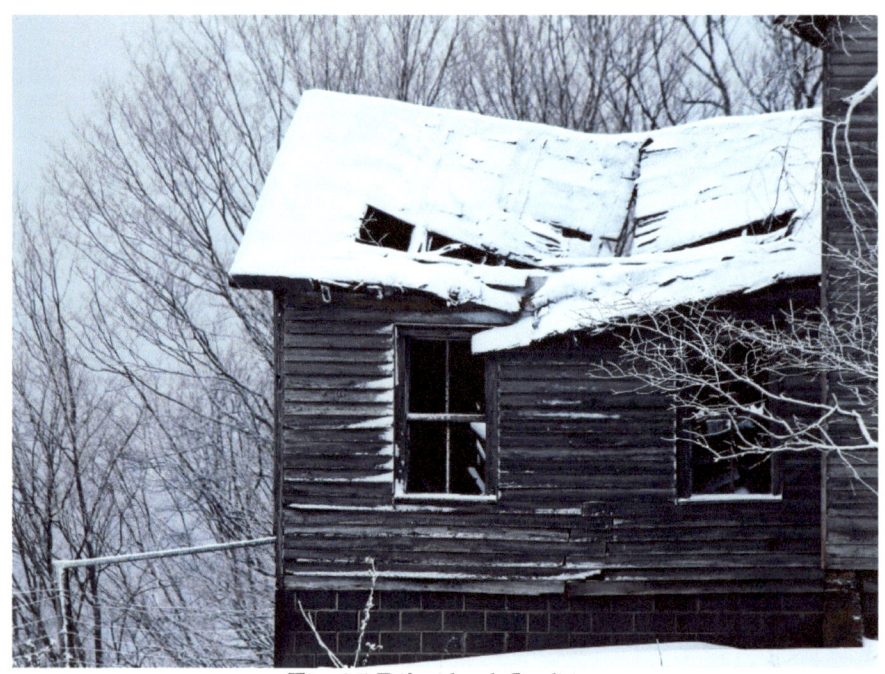

Fig. 6.7 Dilapidated Conditions

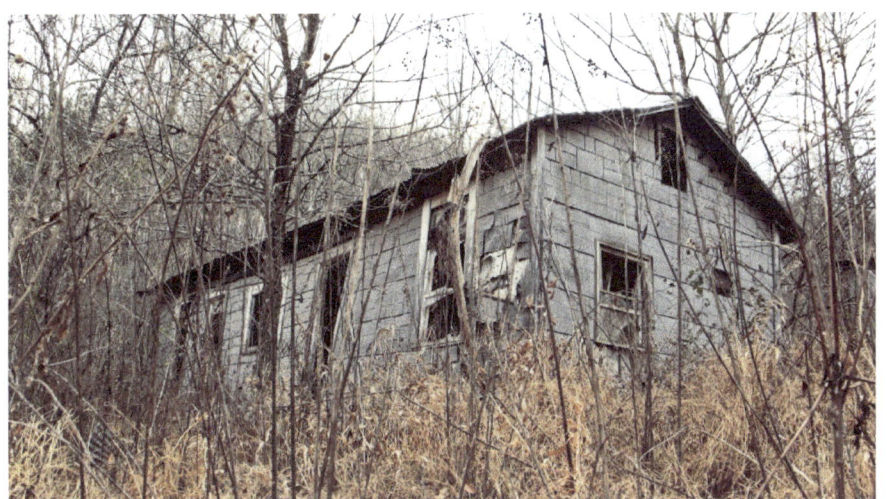

Fig. 6.8 Abandoned House in Doddridge County

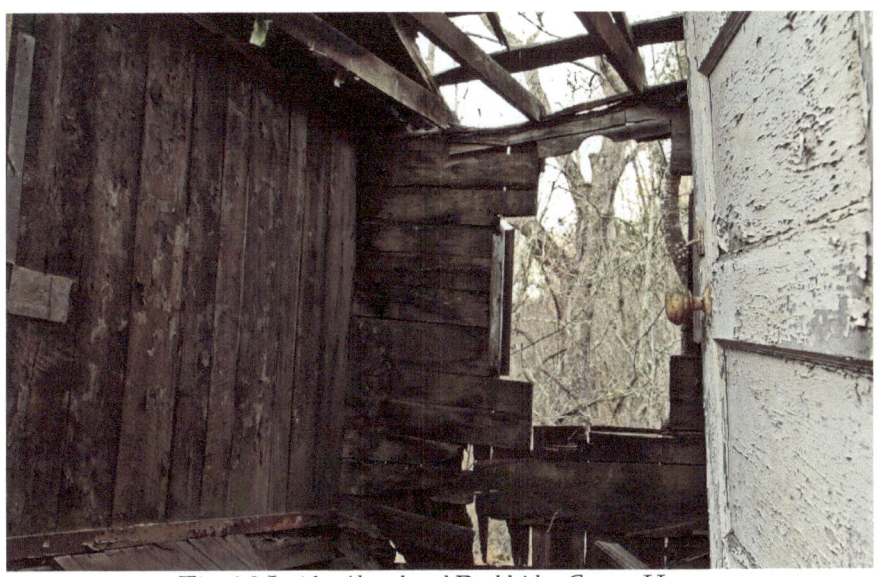

Fig. 6.9 Inside Abandoned Doddridge County House

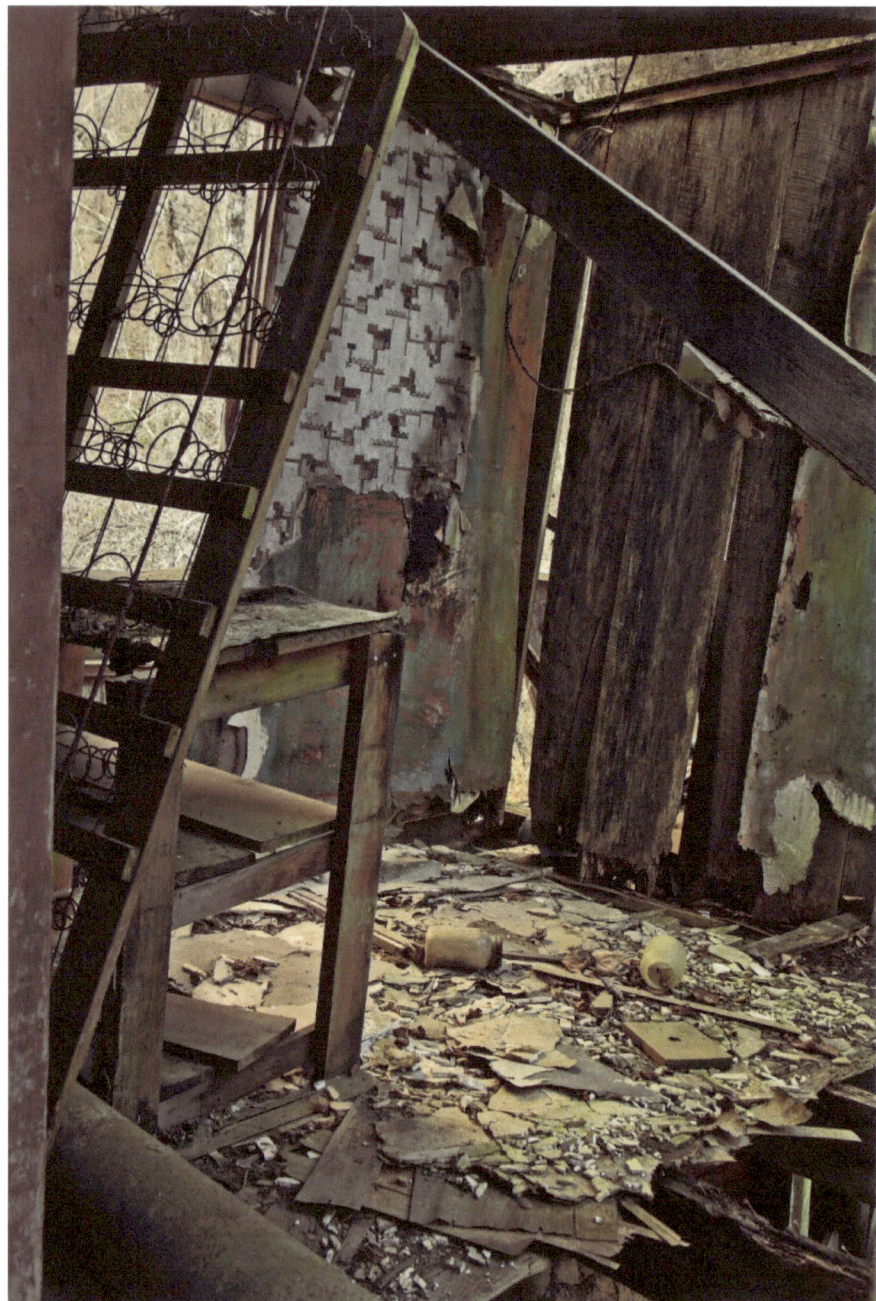

Fig. 6.10 Inside Abandoned Doddridge County House

Yes, West Virginia offers a lot even to those that enjoy searching for the abandoned, ruined, and creepily beautiful.

ABOUT THE AUTHOR

Justin Brewer was born in Weirton, West Virginia, but has lived a few different places. Predominately, he grew up in the northern part of West Virginia, sandwiched between Ohio and Pennsylvania. He graduated from West Virginia University in 2008 with dual Bachelor of Arts degrees in History and English, then proceeded to graduate school at West Virginia University where he obtained a Master of Arts degree in English.

He is also a hobbyist photographer that has learned through advice from others, books, and experimentation. He currently resides in Montana with his wife, Laura, and two young sons, Gabriel and Isaac.

www.ingramcontent.com/pod-product-compliance
Lightning Source LLC
Chambersburg PA
CBHW041150180526
45159CB00002BB/757